QUICK PICKS

Copyright-Free Art for Architects & Illustrators

Eisuke Tanaka + Miyako Fujita

(1) People

GRAPHIC-SHA

g

イラストファイル(1)人物
QUICK PICKS
(1) People

はじめに

われわれデザイナーは，第三者にものごとを伝達するため，抽象的な言葉や目には見えないものを，具体的な形として表現していく機会が非常に多い。伝達の手段や方法はいろいろあるが，もっとも適切で，かつ効果的なプレゼンテーションが要求されている。

われわれを取り巻く社会環境は，時々刻々と変化し多様化し，情報はつねに新しくなっている。そうした新鮮な情報を整理しつつ，第三者にタイムリーな提案，新鮮なイメージを伝達する技量が求められている。プレゼンテーションの絵やイラストやグラフや写真など，ビジュアルな表現が，いくらうまくまとめられていても，第三者に伝えるべき的確なポイントが表現されていなければ，効果的なプレゼンテーションであるとはいえない。

プレゼンテーションはアートではないと認識されながら，表現された内容が，時代的な新鮮さを追及するあまり，過度に奇をてらったり，「絵空事」といわれる虚像の強調で終わっている場合がある。それは相手の意表をつくおもしろいアートとして評価されるかもしれないが，そのプレゼンテーションは必ずしもクライアントへの意志の伝達にはならない。むしろ誤解と混乱を招く結果となっていることもある。

プレゼンテーションは人が人に対して行うのであるから，その中にプレゼンテーターとしてのヒューマンな人間性や思いやりが描かれていなければならない。長年この世界で数多くのプレゼンテーションを手掛けてきた筆者の持論であり結論である。

つまり，われわれはクライアントが実現したい「こと」「もの」「金」「人」に対する考えを読みこみ，それをいかに形として表現するか，意図をわかりやすくし，第三者にいかに思いやりのあるプレゼンテーションをするか，それにかかっている。

いかに大きなプロジェクトであろうと，いかに小さな「こと」であっても，表現すべき意図を必要にしてかつ十分に伝達し，その上にさらにヒューマンなプレゼンテーションが求められていると理解していただきたい。それは，プレゼンテーションの作者の独りよがりや，一方的な押し付けであってはならないのであって，アートとプレゼンテーションの違いを弁えて制作しなければならないということである。

そのために，プレゼンテーションを制作するデザイナーは日常の生活の中から，つねに新鮮な情報の収集を心掛け，経験，体験を深め，感動し，プレゼンテーション以前の幅広く深い見識を自らのものにしていく必要がある。

われわれのまわりには，おびただしい情報や資料やヒントが存在している。その膨大な情報の中から何を選択し何を捨てるか，デザイナーに求められている力量が，そこに問われている。

この本は，われわれがプレゼンテーションを制作する上で必要な表現素材のうち，「人物」を中心に取捨選択し，使いやすくまとめてみた。ビギナーからプロフェッショナルにいたるまでの，非常に幅のひろい読者を想定して，一つ一つの素材をどのように活用すればよいか，具体的な応用表現の作例事例を示したイラストレーションの作品集となっている。

この種の書籍は世界中で数多く出版されている。しかし，その多くは単なる作品集となっている場合が多く，作品の数は多くても使いにくいことが多かった。それは，描かれた絵が傑作であっても，使われる時を考慮していないからではなかろうか。

筆者も膨大な資料を前にして立ち往生することがしばしばあった。多くのプレゼンテーターが日常の制作活動のなかで困っておられるのもここであろう。必要に応じて必要なイラストレーションが即効的に使用できれば，その作業はどれだけ軽減されるかしれない。とくにプレゼンテーションのなかに人物を描きこむのは非常に難しく時間がとられる。

人物の表現素材を簡単に使えるようにするため，アイライン（水平線）を設定し，そのアイラインと人物の頭の位置を一致するように貼りこんでいけば，どの人物も全体としてバランスがとれ，整合性があるシーンが再現されるよう作画した。また，同じ人物の表現素材であっても，シーン（場面）によって使い分けると，その場にふさわしい人物像，違ったイメージの人物として，多様に変化していくよう工夫している。

この本は表現素材のシリーズとして「人物」「樹木」「乗り物」「事物」の4部作のなかの一冊で，コピーフリーである。多くの読者がこのシリーズに掲載した画を参考に，さらに創意工夫され，自らのイラストレーション資料を自分自身で作っていかれることを願っている。この本がその一助になれば幸いである。

（デンコーポレーション代表・田中　英介）

2

FOREWORD

As designers, we have numerous opportunities to express abstract words and images in concrete shapes in order to communicate such concepts to third parties. Although there are many forms and methods of transmitting this data, the most appropriate and effective method is always required.

The society surrounding us is changing minute-by-minute, and new information is continually being presented to us. Under such circumstances, it is our duty to organize this new information, and transmit the fresh images to third parties in a timely manner. No matter how well the visual presentations such as illustrations, graphs and photographs are organized, if the point does not come clearly across to the audience it cannot be said that the presentation is a success.

Even while realizing that a presentation in itself is not a form of art, there are times in which, in order to pursue the freshness of the times, the presenter ends up merely making a display of his/her originality while presenting the data, or the display may result in an emphasis of a ghost image, nearly a fabrication. Although it is true that this type of presentation may surprise and delight the audience as an interesting form of art, it does not necessarily successfully transmit the client's will. Rather, it often results in causing confusion and misunderstanding.

Since a presentation is an act from one human being to another, it must possess a sense of humanity and consideration of the presenter. This is the writer's own theory and conclusion as a person involved in numerous presentations in this field.

In other words, it is our responsibility to accurately grasp exactly what it is that our client wishes to express, in terms of "matter", "objects", "money", and "people". With this accomplished, we must then present these concepts to a third party as a concrete thought with the utmost sense of consideration and clarity.

I would like you to understand that no matter how large the project is, or how small the "matter" may be, it is essential to communicate the thought being expressed in a "human" presentation. The presentation must not be a one-sided view of the presenter's ideas. It is important to realize the difference between a presentation and a mere form of art..

In order to accomplish this feat, the designer producing the presentation must gather from his/her daily life new information, and deepen his/her own experiences. By learning to feel deeply from such new information and experiences, the designer should acquire a deep and wide knowledge of matters prior to the presentation stage.

There is an incredible amount of information, data, and hints surrounding us. A designer's talent is challenged by what data is stored and what is discarded from this vast source of new knowledge.

Of the many materials of expression necessary for a presentation, we have taken "human figures" as the central image of this book, and have organized the content so that the data can be easily used. Assuming that a wide range of readers, from beginners to professionals in the field, will be reading this book, we have used illustrations of concrete examples to carefully describe each individual material.

There are many books on this subject published around the world. However, many are simply collections of works, and although the examples may be numerous, the books are often not practical. I believe that this is because although the examples shown are often superb, on many occasions the writer does not take into consideration the actual user.

From time to time I have also been faced with an incredible amount of data, not knowing exactly what to do with it. This is probably also the point at which many presenters find difficulty in their work. If an appropriate illustration could be used according to the particular purpose sought, this step would be greatly simplified. It is especially troublesome and time-consuming to introduce human figures in a presentation.

In order to make it easy to use human figures as a form of expression, we have set an eye line (horizontal line). If the figure's head is expressed at the same level as the eye line, all figures will be balanced, and a consolidated scene is recreated. We have also planned it so that even if we are using the same figures as a means of expression, by distinguishing them according to the particular scene, appropriate figures, ones with different images, are created.

This book is one of a series of four in which expression materials are introduced, the others being "Plants", "Transportation", and "Miscellany". I hope that many readers will use the illustrations in this series to design even more creatively, and that you will be able to make your own individual illustration data source.

President & Manager, Den Corporation Co., Ltd.
Eisuke Tanaka

イラストファイル
目次

はじめに ……………………………………………………………………………… 2

1．この本の使い方 ………………………………………………………………… 8

 作例：駅 ……………………………………………………………… 14

 コーヒー・ショップ ……………………………………………… 16

 バスターミナル …………………………………………………… 17

 インフォメーション・カウンター ……………………………… 18

 エントランス・ロビー …………………………………………… 19

 ビーチ ……………………………………………………………… 20

 美術館 ……………………………………………………………… 21

 レストラン ………………………………………………………… 22

 オフィス …………………………………………………………… 23

 エアポート ………………………………………………………… 24

 銀行 ………………………………………………………………… 25

 スーパーマーケット ……………………………………………… 26

2．表現素材としての人物

 1．住宅の中の人物 …………………………………………………… 27

 2．住宅周辺の人物 …………………………………………………… 69

 3．社会生活と人物 ………………………………………………… 119

TABLE OF CONTENTS

.. 2

1. *How to Use this Book* 8

 Station 14

 Coffee Shop 16

 Bus Terminal 17

 Information Counter 18

 Entrance Lobby 19

 Beach 20

 Museum 21

 Restaurant 22

 Office 23

 Airport 24

 Bank 25

 Supermarket 26

2. *Figures as Materials of Expression*

 1. Figures within the House 27

 2. Figures outside the House 69

 3. Figures and Society 119

Quick Picks

Copyright-Free Art for Architects & Illustrators

By Eisuke Tanaka & Miyako Fujita

Copyright 1991

All right reserved No part of this publication may be reproduced or used in
any form or by any means—graphic, electronic or mechanical, including
photocopying, recording, taping, or information storage and retrieval
systems—without written permission of the publisher.

ISBN 4-7661-0575-3 C3052

Manufactured in Japan

First Edition February 25 th 1991

Graphic-Sha Publishing Co., Ltd.

1-9-12, Kudan-kita, Chiyoda-ku

Tokyo 102, Japan

1. この本の使い方

この本の使い方

　この本には，表現素材としての人物イラストレーションが収録されている。建築プレゼンテーションをはじめ，学級通信，社内報，ミニ・コミュニケーションなど，印刷媒体の人物イラストレーションとして活用できる作品集である。大いに活用していただきたい。

　実際の使用にあたっては，どの表現素材をどこにどのように使えばもっとも効果的であるか，十分検討し，イラストレーションを切り抜いたり組み合わせたり，その場（シーン）の雰囲気に合った情景を創造するよう，工夫していただきたい。

　この本のイラストレーションは，読者が使いやすいように，同じ素材を大きさを変えたり，反転させたりしたものもある。最近出回っている新しいタイプのコピー機器には，ミリ単位で縮小拡大したり反転が可能なものもある。こうした機器の機能を使って，自分の表現にもっとも適した素材として活用できる。

　もっとも肝心なことは，表現しようとするシーンに自然に溶け込む素材選びとレイアウトであり，スケール感の整合性である。また，これらの素材に陰影やタッチを加えると，この本のイラストレーションの丸写しではない，よりリアルなシーンが表現できる。さらに，読者が身の回りにある素材や情報を，常日頃から整理され，本書に収録した要領で，自分なりのオリジナルな素材づくりを試みていただきたい。素材が豊富であれば，画面に表現される情報の量が豊富になり，それを見る人に親しみやすさ，作者のホットな心情が伝えるられる。ふだんの心掛け次第で，いつでも使えるイラストレーションが無限に増やせるはずである。

　素材選びの手順としては，どの素材をどのように使えば効果的か，プレゼンテーションの前提としてのシナリオを描いてみることをお薦めしたい。映画やドラマやテレビのシナリオほどではないにしても，自分の日常の体験などを思い浮かべ，時・場所・何を・どんな季節というふうに考えて，素材を選ぶ。

　次にそれを骨組みにして組み合わせたり，並べ変えてみたり，寸法を変えてみたりして，実際の画面の上で，シミュレーションする。何回か並べ変えていくうちに，その場（シーン）にふさわしい情景が創造されいく。確定したところで，貼りこんでいけばプレゼンテーションが完成する。

加工要領

　作画に手慣れておられるベテランは別として，ビギナーのために若干の説明を加えておきたい。本書の素材を十分に活用するには，次のような順序で作業を進めていくと便利である。

1．シナリオを描く

　プレゼンテーションの相手に対して，どのようなシーンを提案すれば，プレゼンテーションの内容が理解されやすいかを考えてみる。屋外か，室内か，ホテルかレストランか，公共施設なのか，季節は？など提案すべき条件は無数にある。与えられたその条件を一つ一つクリアーしていくつもりで，自分なりに思いつくまま情景を箇条書きにメモしてみる。

　その中から全体との調和や整合性，作者としての相手に対する「思いやり」などを描きこんでいけば，生き生きとしたシーンとなっていく。

　シナリオのうまい下手は問題ではなく，そのプレゼンテーションを生かすも殺すも，添景として登場させる人物によって，情景が大きく変わっていく点に留意していただきたい。シナリオがしっかりしていれば，そのプレゼンテーションは，心のこもった作品として仕上がっていき，相手にプレゼンテーションの意図が的確に伝わっていく。

2．素材選び

　次に，シナリオに基づいた素材を選んでみる。いくぶん余分に選んで，必要ではないものを捨てるようにすると，作業時間が短縮できる。余分に作っていらないものを捨てる，これがコツである。使わないものは，残してスクラップしておけば，何かの時に役立つ。

3．サイズの調整

　シーンの中で描いたシナリオに沿って，どの素材をどれくらいの大きさで使うかを決める。仮に本書の原稿寸法を10とし，使用する寸法が7であれば，70％に縮小する。逆に大きく使いたいときは寸法に合わせて拡大する。縮小率をさまざまに変えて，寸法の違うサイズの切り抜きを，あらかじめまとめて作っておけば手間が省ける。

4．反転してみる

　表現素材を反転して使うと，思いがけない効果が出せる。本書には同じ表現素材を反転したイラストレーションも掲載しておいたので，それを選び出し組み合わせてみるとよい。

5．コピーして切り取り，貼ってみる

　必要な素材をコピーし，ハサミやカッターで，アウトラインぎりぎりのところで切り抜く。細い線の集合や隙間は，大まかなアウトラインを設定し，面として切れば使いやすい。貼りこみは，着脱可能なデザイン用スプレー糊を使えば，レイアウトするとき便利である。

6．糊つきコピーシートの利用

　乾式コピーシートには，糊つきシートがある。コピーしたシートをカッターで切り抜くだけで接着できるようになっており，すぐ使えるから便利である。シートは半透明タイプと不透明なタイプのものがある。半透明のタイプは下地の線が見えたりして，後で消すのが面倒だからあらかじめ貼り合わせる部分を消しておく。

7．コスチュームを変える

　季節の違いを強調する場合は，着衣を変えた方が効果的であり，また屋外用として描かれている人物を，室内用として使う場合は，履物を変えるなどの，細かく配慮して場面の整合性を考える必要がある。

8．ホワイト修正液によるタッチアップ

　素材が手前の情景に遮られる場合，素材を一部カットして貼りこんだり，またはホワイト修正液で重なり合う部分を消去し，後で加筆すれば，奥行きが出せる。

9．同じ素材の連続で群を表現する

　人物，車，樹木などの大きさを少しずつ大きさを変えて連続させると，集合体や群を表現することができる。樹木などは同一素材を反転させるだけでも，違った樹木に見えるし集合体に変化がつく。

10．素材のタッチアップ

　貼りこんだ素材が，地面や床に接する部分にサインペンなどで，陰影を入れると，表現にリアリティが出てくる。また，素材に影をつけ加えれば立体感が出せる。

11．水平線は見る目の高さを表す重要なライン

　使用する素材を選び，表現シーンの中に配置するとき，必ずシーンの中に水平線を意識して並べていく。この水平線は作画上のアイレベルであると同時に，作画の基本である。つまり物を見る人の目の高さを表すものである。その高さは成人の場合，G.L.（地面／グランド・ライン）から約1.5〜1.6メートルを想定して描いておき，素材もこの線をイメージしてレイアウトしていけば，自然なアングルとして収まっていく。

　高さを変え，見る目の高さを20メートルから30メートルに設定すると俯瞰図（バーズアイビュー）になる。

12．素材をアイレベルラインに揃えて配置する

　人物の配置はおおよそ人物の頭がアイレベルに並ぶように配置すると収まりがよくなる。子供や幼児は成人に対する大きさで決めていくとよい。自動車を描きこむ場合は，屋根の高さを人物の頭の位置よりも，やや下にすれば，スケール感が合ってくる。

　樹木や事物も人間の高さとの関係を意識しながら大きさと配置を決めていく。その基本はアイレベルである。

著者注：

1．縮小・拡大と反転ができるコピー機器

　●メーカー名：キヤノン
　　機種名：NP-9130 レーザーコピー（モノクロ）
　　　　　　PIXEL-200（カラー）
　　　　　　PIXEL-DiO 200（カラー）
　●メーカー名：リコー（デジタル複写機）
　　機種名：イマジオ 420V（モノクロ）
　　　　　　アーテージ 8000 REALA（カラー）

2．接着糊がついているコピーシート

　●メーカー名：いずみや
　　商品名：タックフィルム（マット／半透明）
　　　　　　タックフィルム（グロス／透明）
　●メーカー名：リコー
　　商品名：リコピー PPC用紙（ハクリ用）ノーカット 0面
　●メーカー名：桜井（株）
　　商品名：スタートレーパー
　●メーカー名：前島加工所
　　商品名：前島ハクリ紙

（いずみや／カネコ商事調べ）

How to Use This Book:

Within this book you will find a collection of human figure illustrations as a form of expression material. The examples may be used in presentations, as well as in school communications, company news letters, mini-communications, or any other form of publication. We hope that you will take full advantage of this book.

When actually using this book, we would like you to carefully decide which materials should be used where to be the most effective, and to then use your imagination in cutting out the illustrations, combining them in different ways, and creating an atmosphere which suits the scene best.

In order to aid the readers in using this book, we have, in some cases, introduced the same material in different sizes or in the reverse. There are several copy machines on the market today that enable the user to reduce and enlarge the image in units or millimeters, or even reverse the image. Try using one of these machines to create the material most suited to your expression and purpose.

The most important thing is choosing the material and layout that blends with the scene being expressed the most naturally, as well as the conformity to scale. In addition, if an extra touch and shades are added to the illustrations, a realistic scene, one not merely a copy of this book, can be expressed. We would also like you to gather and organize from your daily lives materials and information such as those found in this book, and attempt to create your original material. If the materials are abundant, the data being displayed will also be abundant, transmitting a sense of warmth to the viewer. By paying careful attention to such details, you should be able to create an infinite store of illustrations that can be used for all purposes.

In selecting the most effective material, I would like to suggest that you create a simple scenario as a premise to your presentation. Although it does not have to be as extensive as one created for a TV program or a movie, you should imagine experiences that you have had, and select the material in terms of time, place, object, and season. Once you have done this, use it as the framework of your scenario, change the combination, layout, or dimensions, and simulate it on the actual display. By repeating this process several times, you should be able to create an atmosphere perfect for the scene.

At this point, simply apply the material to the display, and the presentation will be completed.

Processing Technique:

For those of you who are not well-acquainted with the techniques of drawing, we would like to explain some of the basics. In order to effectively use the materials introduced in this book, it is convenient to do so in the following order.

1. Creating a Scenario

Think about what kind of scene will aid the presentation's audience in understanding the content. Is it outdoors, indoors, a hotel, restaurant or public facilities? What is the season? There are numerous factors to consider. In an attempt to cover all of the given conditions, write down as many scenes that come to your mind.
By selecting the scenes from the list that have the most harmony with the whole, those that conform to the overall picture, ones that express the sincerity of the designer to the audience, you should be able to create a lively scene.
Whether or not you are adept at creating the scenario is not important. Remember that the presentation can either be a success or a disaster by the selection of human figures chosen, since they are what can drastically change the atmosphere and scene. If the scenario is sound, the presentation will be one with warmth, and the audience will be able to accurately comprehend the purpose of the presenter.

2. Selecting the Material

Based on the scenario, select the material. By selecting slightly too much, you will be able to later eliminate what is not important, thereby reducing the time of preparation. Remember to make extra and to eliminate what is not needed. Keep what you did not use for a later date.

3. Adjusting the Size

Follow the scenario to determine what size to make each material. Assuming that the size of a figure is 10 in this book and you wish it to be 7, reduce it to 70%. If you need it to be larger, enlarge it accordingly. Time and trouble can be saved by making a number of different sized cutouts in advance.

4. Reversing the Image

An unexpected effect can be obtained by reversing the material. We have introduced reversed images of the same material in this book, so try different combinations of these to test the effect.

5. Copying and Cutting Out the Material

Copy the necessary material and carefully cut out the outline using a knife or scissors. For areas with fine lines or empty spaces, establish a rough outline and cut it out. When applying the figure to the actual surface, use a removable spray-type adhesive. This makes it easy to try different layouts.

6. Using Copy Sheets with Adhesive

You may choose to use dry copy sheets with an adhesive. This type of paper is convenient in that all you are required to do is copy the image and cut it out, since the adhesive is already applied to the sheet. There are semi-transparent and opaque sheets available. Since you can often see the lines of the base when using the semi-transparent sheets, and it is difficult to erase them later, erase the lines before attaching the figures.

7. Changing the Costume

When emphasizing the seasonal difference, it is effective to change the clothing. Also, if you are going to use a figure originally used for an outdoors scene for one indoors, remember to change the shoes. It is important to take into consideration each detail and the conformity of the scene.

8. Touching Up with Correction Liquid

If the figure is obstructed by another object, remove part of the figure before attaching it, or erase the overlapping area using a correction liquid. By retouching the scene later, a sense of depth can be created.

9. Expressing a Group with a Sequence of the Same Material

By displaying a sequence of figures, cars, and trees that are of slightly different sizes, a gathering or group can be expressed. A different atmosphere can be created by simply reversing the trees, thereby giving the gathering variety.

10. Touching Up the Material

Use a felt pen to shade the areas where the figure touches the ground or floor, giving the expression a sense of reality. By adding a shadow to the figure, it will become more three-dimensional.

11. The Horizon is an Important Line Expressing the Eye Line

When selecting the materials and arranging them within the scene, always do so with a horizon in mind. This horizontal line is the eye level, as well as the basis of the drawing. In other words, it is the eye level of the figures looking at an object. The line should be approximately 1.5 to 1.6 meters from the G.L. (Ground Line) in the case of an adult. Draw the line and apply the figures to create a natural angle.
By changing the height, and by setting the eye level at 20 to 30 meters, you can create a bird's-eye view.

12. Arranging the Material Along the Eye Level Line

Arrange the figures so that their heads are level with the eye level. For children and infants, determine the height in comparison to the adult figures. Draw cars with the height of the roofs slightly lower than the human heads to keep them in perspective. Arrange trees and other objects in relation to the human figures, as well. The basis is always the eye level.

場面設定のシーンがおおよそ決まった時点で，素材から適切な人物を選ぶ。サイズを調整し，反転などを試み，コピーしたうえで切り取って準備する。

Example of the designing process

When the setting is selected, choose a suitable character from the material, adjust the size, try reversal and detach it. Place it in the illustration underneath, tape it down and zerox it.

Draw details on it and devise how to make perspective among characters. The trick is to place a child in proper proportion to adult's height. Shadows at the feet bring out reality in characters.

下図の中に切り取った人物をレイアウトし，テープで固定してコピーする。それをベースに細かいデテールをペンで清書していく。人物に遠近感が出るように工夫し，子供の頭の位置は大人の身長との割合で決めるのがコツである。足元に影をつけると人物にリアリティが出て効果的である。

■無人駅■

この絵のままでは，その駅がどんな駅かわかりにくい。どんな駅の性格にするか，じっくり眺めて情景を思い浮かべてみる。プレゼンテーションのコンセプトが決定している時は，それを箇条書にして，具体的な情景として描いていく。

Unstaffed Station

It is difficult to imagine what kind of station this is going to be from this drawing. Take some time to look at it and imagine the scene. If the presentation's concept is decided, make a list and draw in the figures as a concrete image.

駅名は省略してあるが，必要に応じて駅名をレタリングすると，何線の何駅であるかがはっきりする。

Although we have not included the name of the station here, if necessary, use lettering to show the station name. This will make it clear which station, on which line, it is.

背景の看板は全部描きつぶさないで，すこし残しておく。

Do not draw in all of the details of the signs in the background.

遊びにでかける家族で和やかさを表現。

Express a sense of harmony through a family going off to enjoy the day together.

駅舎の高さに合わせて，アイ・ラインを薄く引いておく。

Draw a thin eye line at the height of the station building.

若い父親と幼子で休日を表現。

Express a holiday by using a young father and child.

■東京近郊の駅■

シナリオ・ノート：

東京近郊の昼下がりの駅。休日。買い物，遊園地，旅行に出掛ける人などが，電車の到着を待っている。季節は初秋か春のはじめ。

殺風景な無人駅も，この図のような人物を描き添えることで，シナリオとして場面設定した駅の性格がはっきりしてくる。

人物を横一列に並べるだけでなく，前後関係に変化を持たせることで，その駅の性格がいっそうはっきりしてくる。

単純に人物を埋めようとしないで，通勤通学のターミナル駅を設定した駅であるとするなら，通勤する乗客や通学する制服の学生などでまとめていくように工夫する。

Station in Tokyo's Suburbs

Scenario Note:

Early afternoon in a station in Tokyo's suburbs. Holiday. People waiting for the train to go shopping, to an amusement park, traveling. The season is early autumn or spring.

By adding human figures such as those shown here, even the bleak unstaffed station gains a definite personality according to the scenario.

Rather than arranging the figures in a strait horizontal line, by adding variety to their positions the station is given further personality. Remember not to merely fill the station with people. For example, if the station is a terminal station for commuters, make sure that the figures are dressed accordingly. Add students wearing uniforms, and so forth.

●ワンポイント・アドバイス

設定シーンにふさわしい人物を選びコピーする。
成人の頭の高さに合わせて，人物を貼りこんでいく。

Advice:

Select figures appropriate for the imagined scene and copy them.
Attach the figures in accordance with an adult's head level.

ストールをはおった中年の女性で，春と秋の季節を表現。

Express spring and autumn by adding a middle-aged woman wearing a shawl.

旅行に出掛ける若夫婦で週末を暗示させる。

Give the idea of a weekend by showing a young couple taking a trip.

発車していく電車で画面に動きが出てくる。

Add movement to the scene by showing the train leaving the station.

まばらに電車を待つ乗客で，郊外の昼下がりを表現。

Express an early afternoon in the suburbs through scattered passengers waiting for the train.

■無人のコーヒーショップ■

このままではレストランなのか，どんなコーヒーショップなのか分かりにくい。

Unstaffed Coffee Shop

It is difficult to tell whether or not this is a restaurant; or what kind of coffee shop it is.

■住宅街にあるしゃれた雰囲気のコーヒーショップ■

シナリオ・ノート：

常連客で賑わうコーヒーショップ。和やかな雰囲気。ゆったりした店。談笑する客。新聞を読む客。語りかけるマスター。褒められて照れるママ。経営者の心暖まるもてなしで繁盛している。

Fancy Coffee Shop in a Housing District

Scenario Note:

Coffee shop full of activity with regular customers.Peaceful atmosphere. Comfortable shop. Laughing customers. Customer reading a newspaper. Proprietor speaking to customer. His wife blushing after being praised. The coffee shop is prospering because of the warm hospitality of its owners.

●ワンポイント・アドバイス

ママとマスターの配置を工夫し（店の魅力はマスターとママの家庭的な雰囲気であることを表現してみた）。

人物を入れ替えるとがらっと違った雰囲気になる。

笑顔で明るい談笑を表現した。

さまざまな客がいることで，幅広いお客に支持されている店を表現。

Advice:

Use your imagination in arranging the proprietor and his wife. We have tried to express here the charm of the shop, the warmth of this couple.

By changing the figures, a completely different atmosphere is created.

A happy atmosphere was created through the use of laughing figures.

By showing a variety of customers, we have shown that the shop is popular among a wide range of people.

■バスターミナル■

シナリオ・ノート：
郊外の駅前。バスターミナル。三々五々，2番乗り場でバスを待つ人たち。のんびりとバスを待つ。

Bus Terminal

Scenario Note:
In front of a suburban station. Bus terminal. Groups of people waiting for the bus at stop No. 2. Leisurely waiting for the bus.

●ワンポイント・アドバイス

駅のシーンで使用している親子の姿であるが，場所が違えば，このように違って見える。

ビジネススーツに身を固めた男女を適当にアレンジし，乗り場のサインに向かって整然と並ばせると，通勤の場面になる。

学生服やユニフォーム姿の女子学生が並んでいると，通学のシーンになる。

ボストンバッグ姿が多ければ観光地が演出できる。

Advice:

Although we have used the same parent and child shown in the station scene by changing the background they look this much different.

Randomly arrange men and women in business suits walking towards the bus stop signs to express a commuting scene.

Add young boys and girls in uniforms to show commuting students.

Add small suitcases to express a tourist resort.

■ゆったりしたインフォメーションカウンター■

人物を画面手前や奥に配置したり，その中間に配置して工夫すると全体に奥行きが出せる。

Comfortable Information Counter

An overall sense of depth is expressed by arranging the human figures to the front, back and middle of the scene.

●ワンポイント・アドバイス

ズボンに手を突っ込んだ客で，気軽な雰囲気を表現してみた。
男性客ばかりでなく，女性客を入れこめば賑やかさが出てくる。

Advice:

A casual atmosphere has been created by showing a customer with one hand in his pocket.
The scene will be more cheerful when female customers are included in addition to the men.

スーツに身を固めたビジネスマンで，オフィスらしさを表現してみた。画面左下で談笑している二人が，この画面で重要なポイントになっている。ロビーの遠近感と画面のフレームが，この二人で決まる。
アイラインは建物の高さと人物の配置などを考慮して決める。

Entrance Lobby of an Active Office Building

An office was expressed through the use of businessmen in tailored suits. The two figures casually talking to each other to the bottom left are important to this scene. The lobby's perspective and the frame of the scene are created by these two.
Determine the eye line with the height of the building and the positions of the figures in mind.

■ビーチ■

シナリオ・ノート：
海水浴。サーフィンもできる。静かな浜辺。

Beach

Scenario Note:
Swimming in the sea. Surfing. Quiet beach.

●ワンポイント・アドバイス

この絵の場合，水平線がアイラインになる。
椰子の樹の並木（樹木編から）で，南島の海岸を表現。
親子づれで泳げる海辺を表現。
子供は成人の大きさに比例して背丈を決める。
この情景は海に向かう親子であるが，反転して使えば，泳いだ帰りの情景に変化する。
サーフィン・ボードを４ＷＤ車（乗り物編）から降ろす若者たちで，波乗りもできる海辺であることがわかる。
注：人で混雑するリゾート海辺を表現するよりも，人物はこの程度にとどめておいた方が無難である。群衆を表現したい場合は，寝そべっているモデルを探し，くどくない程度に砂浜にさりげなくつけ加えるとよいだろう。登場人物を変えることによって，情景がガラッと変わることをシミュレーションしていただきたい。

Advice:

In the case of this drawing, the horizon is the eye line.
Palm trees (from the Tree Series) are used to express a beach from a southern island.
A beach where families can enjoy swimming has been expressed.
Determine the height of the children in relation to the adults.
Although this scene shows a parent and child walking towards the ocean, when it is reversed it becomes a scene of the same people walking back after a swim.
By showing young surfers removing their boards from a 4WD car (from the Vehicle Series), we know that the ocean here is suited for surfing, as well.

Advice:

Rather than showing a resort beach crowded with people, it is safer to limit the number of figures as shown here. When it is necessary to introduce a crowd, look for lying models and casually add them to the scene. Try simulating different scenes by varying the figures.

■美術館■

シナリオ・ノート：
鑑賞する人。

Museum

Scenario Note:
People appreciating the art.

●ワンポイント・アドバイス

画面手前に人物を配置した。
それぞれ，頭の方向，目の位置をそろえ方向性と整合性に
気をつける。人物はあまり多く使わない方がよい。
アイラインに注意しながら配置する。
左の女性の表情を変えると，シリアスな絵が掛けられてい
るか，微笑を誘う絵を鑑賞しているか，表情に動きが出て
くる。人物は思い切って大胆に使えば，効果的である。

Advice:

People are positioned to the front of the scene.
Pay attention to the direction and conformity by making
sure that the heads and eyes are pointed in the same
direction. It is best not to use too many human figures.
Pay attention to the eye line when arranging the figures.
By changing the expression on the face of the woman to
the left, it is possible to convey whether she is looking at a
serious picture or one of a comical nature. It is most
effective to use bold figures.

■高級レストラン■

シナリオ・ノート：
高級レストランのイメージ。良質なサービス。

High-class Restaurant

Scenario Note:
Image of a high-class restaurant. Excellent service.

●ワンポイント・アドバイス

家族連れ，友人同士と二組のグループで高級レストランの
雰囲気を出してみた。
画面手前のアーチと植物がアクセントポイントになっている。

Advice:

A high-class atmosphere is shown by introducing two
groups: a family and a group of friends.
The accent is the arch and plants to the front of the
scene.

■オフィス■

シナリオ・ノート：
オフィスの内部。ディリングルーム。

Office

Scenario Note:
The interior of an office. Dealing room.

●ワンポイント・アドバイス

シーンをディリングルームとして設定してみた。
壁をガラスで表現すれば，外の景色が見える一般的なオフィス空間の表現となる。

Advice:

The scene is a dealing room.
By making the walls glass, an ordinary office, one in which the workers can see outside, is expressed.

■エアポート■

シナリオ・ノート：地方都市のエアポート。

Airport

Scenario Note: A local airport.

●ワンポイント・アドバイス

画面右手の人物像。左端の人物像の大きさを変えたのがポイントである。（同じ大きさでは，遠近感が出ないうえ，ロビーの広さが感じられない）
アイラインを中心に人物を配置し，変化を出す。

Advice:

Note that the size of the figures to the right and left have been altered. (If they were the same size, a sense of depth and the size of the lobby would not be conveyed.) Position the figures around the eye line to add variation.

■銀行■

シナリオ・ノート：天井の高い銀行内部。

Bank

Scenario Note: Interior of bank with high ceiling.

●ワンポイント・アドバイス

アイラインに注意しながら，人物の頭の位置を決めていく。
カウンターの高さに対して，人物の背丈を2倍に設定する
とバランスがよくなる。

Advice:

*Determine the positions of the human heads by paying
attention to the eye line. The height of the cars should be
slightly lower than an adult's head.
Position other figures according to the woman to the left
so that a sense of depth is conveyed.*

■スーパーマーケット■

シナリオ・ノート:
日常のシーンを絵にするのはなかなか難しい。買い物客を主にするか，陳列商品を主にするかで雰囲気が変わる。ここでは陳列ケースと商品をポイントにしてみた。

Supermarket

Scenario Note:
It is difficult to draw an ordinary scene. The atmosphere changes depending on whether the shoppers or the goods lining the shelves are stressed. We have emphasized the latter here.

●ワンポイント・アドバイス
中央の陳列ケースを主にして構成し，人物は添景とした。
アイラインと陳列ケースの高さの整合性をまとめる。

Advice:

Emphasis is placed on the central case, with human figures to the sides.
Pay attention to the conformity of the eye line and height of the display case.

2.表現素材としての人物

1. 住宅の中の人物

QUICK PICKS

1. Figures witnin the House

群衆 1.

群衆は描き方も使い方も非常にやっかいだが，プレゼンテーションの世界ではわりに
多く使われる。本書の表現素材によって，アイ・レベルで簡単に群衆シーンをつくる
作例と方法を掲載しておく。多くの人を後ろ姿に描いたのは，その場において，何か
が行われているという暗示を与え，その場面の情景に参加できる期待感を引き出すた
めである。この画面では，ロックコンサート，サイン会，バーゲンセールの会場など，
さまざまな情景がイメージできる場面を設定してみた。

群衆 2.

群衆 1 のシーンを縮小し，その手前にさらに人物を次々に貼りこんでいくと，画面全
体が賑やかになる。ここでも成人の頭の高さを水平線として揃え，群衆の塊としての
整合性を考えながら貼りこんでいけばよい。

Crowd 1:

Although it is rather difficult to both draw and use crowds, they are often used in the field of presentations. We will give examples and methods of how to use the different materials of expression found in this book to create eye-level crowd scenes. Many of the figures are shown with their backs toward the audience to give the idea of action at the scene, and to bring out a sense of anticipation in the audience. We have created here a scene that could be used to imagine situations such as a rock concert, autograph party, or a bargain sale.

Crowd 2:

By reducing the size of the scene in "Crowd 1," and by adding more figures to the front, the overall scene has become more lively. Once again, we have used the height of an adult's head as the horizon, and have added the figures with the conformity of the crowd in mind.

群衆 3. ◑

前ページと同じ要領で人物を増やしていく。祭日のイベント会場，アミューズメント・
パーク，歩行者天国などのイメージがふくらんでいく。

群衆 4.

画面手前と奥，さらにその奥と距離感を考えながらレイアウトしていく。人物の種類
を変えることによって雰囲気はガラリと変わっていくので，全体の調和を考慮しなが
ら人物を選び配置する。

Crowd 3:

Use the same method as the previous page to add figures.
The image is one of a holiday event hall, an amusement park, or a car-free mall.

Crowd 4:

Plan the layout with a perspective of depth in mind, taking into consideration the distance between the figures to the front and back of the scene. Since the overall atmosphere completely changes depending on the type of figure chosen, take into consideration the harmony of the scene when selecting and positioning the figures.

イラストファイル（人物編）
Quick Picks
1991年2月25日初版第1刷発行

著者　　田中英介＋藤田　都（たなか えいすけ＋ふじた みやこ）

発行者　久世利郎

印刷所　錦明印刷株式会社

製本　　大口製本株式会社

写植　　三和写真工芸株式会社
　　　　洋書印刷株式会社

発行所　株式会社グラフィック社
　　　　〒102 東京都千代田区九段北1-9-12
　　　　電話 03-3263-4318(代表)　FAX 03-5275-3579
　　　　振替・東京3-114345

［スタッフ］
著者　　　　田中英介＋藤田　都
企画・編集　鶴　九皋
デザイン　　清野尹良
翻訳　　　　レスリー・ハリントン
和文写植　　浜田　健
英文写植　　矢追秀紀

Staff:
Authors: Eisuke Tanaka, Miyako Fujita
Editorial Director: Kyuko Tsuru
Art Director: Tadayoshi Seino
Translator: Leslie Harington
Typographic Director: Ken Hamada
English Typesetter: Hidenori Yaoi

著者略歴:
●田中英介（たなか　えいすけ）
一級建築士事務所　デンコーポレーション代表
1948年東京生まれ
1970年工学院大学建築科卒業
　　　同年大栄住宅(株)に入社，納賀雄嗣氏に師事
1977年(株)デンコーポレーションを設立
　　　以来，表現デザインを中心とした業務を展開，大学・専門学校，各種企業の
　　　プレゼンテーション講座などによって，設計技術者の表現力の向上に努めている。

著書:
『建築プレゼンテーションテクニック』(グラフィック社刊)，『インテリアパーステクニック』
(彰国社刊)，『実践住宅パース講座』(彰国社刊)

●藤田　都（ふじた　みやこ）
1966年東京生まれ
1986年東京職業訓練短期大学室内造形学科卒業
　　　デンコーポレーションを経て，現在オフィス由岐（パーススタジオ）に勤務中。

ISBN4-7661-0575-3 C3052